Brush With
Greatness

# Vermeer

Nicole K. Orr

Printing   1        2        3        4        5        6        7        8        9

Cézanne
Gainsborough
Goya
Leonardo da Vinci
Michelangelo

Monet
Rembrandt
Renoir
Van Gogh
Vermeer

**Publisher's Cataloging-in-Publication Data**
Orr, Nicole K.
   Vermeer / written by Nicole K. Orr.
      p. cm.
Includes bibliographic references, glossary, and index.
ISBN 9781624693274
eISBN 9781624693281
1. Vermeer, Johannes, 1632-1675—Juvenile literature. 2. Painters—Netherlands—Biography—Juvenile literature. I. Series: Brush with greatness.
 ND653.V5 2017
 759.9492
**Library of Congress Control Number:** 2016957440

**ABOUT THE AUTHOR:** Nicole K. Orr has been writing for as long as she's known how to hold a pen. She is the author of more than eight books for Purple Toad Publishing and has won National Novel Writing Month nine times. Orr lives in Portland, Oregon, and camps under the stars whenever she can. When she isn't writing, she's traveling the world or taking road trips. When it comes to her own skills as an artist, Orr mostly doodles eyeballs.

**Previous page:** *Girl Interrupted at her Music, 1660–1661*

# Contents

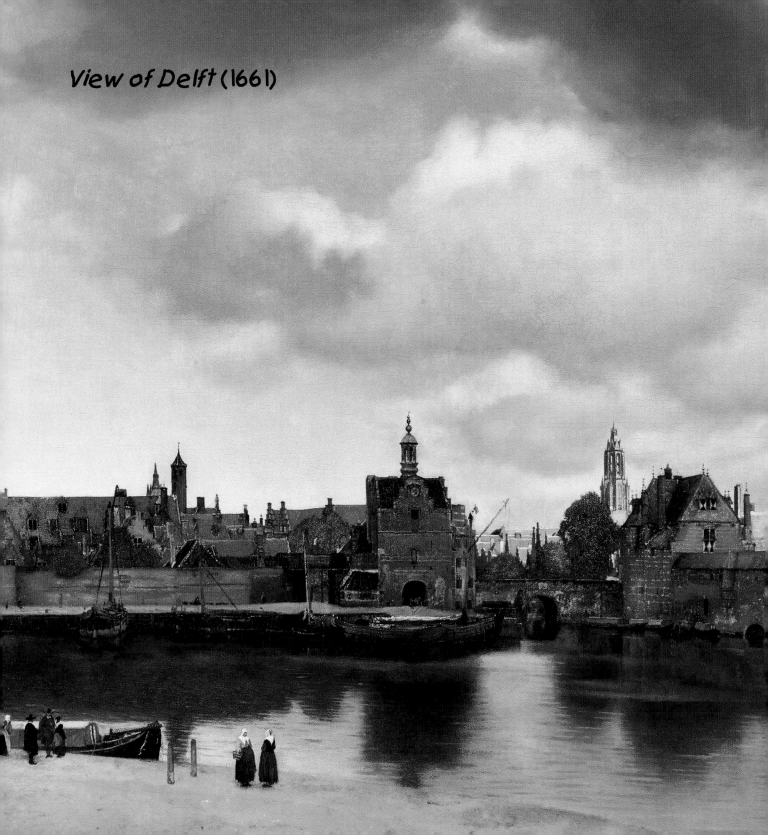

View of Delft (1661)

# Chapter 1
## Meeting the Artist

Jasper **(YAH-sper)** sniffed his hands and smiled. He smelled like apples! He had spent the whole morning peeling apples for his mother and father. They were bakers in the city of Delft, Holland, and Dutch apple pies were their specialty. Now he was walking along the Old Delft, the river that ran through the city. In the distance, Jasper could see the Old Church and the New Church. Their towers soared above the cobblestone streets.

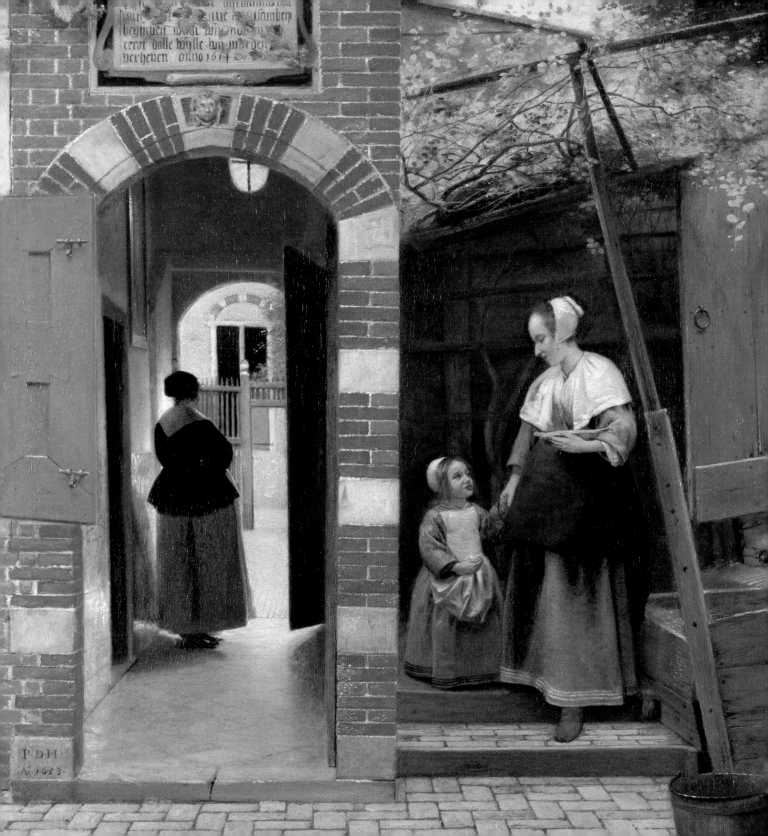

He moved quickly so that he would not be late to meet an important painter named Johannes Vermeer. When he finally reached Vermeer's home, a lady answered the door. "Hello," she said. "I am Catharina. I am the artist's wife."

While Catharina took Jasper upstairs to the workshop, she told him about their eleven children. She spoke with a tired happiness. It was how Jasper's mother sounded when she'd spent the whole day making pies.

The city of Delft was a maze. It was made up of tiny alleys and winding stairways, as can be seen here in Pieter De Hooch's painting *The Courtyard of a House in Delft*.

Vermeer's workshop was a mess! Clothes littered the floor. Bowls of barely touched stew and porridge were scattered around the room. However, one corner was clean and neat. In it was a small table draped with a thick red cloth. A colorful bowl of fruit sat on the table.

"You have apple peels in your hair," said Vermeer. He stood in front of an easel (EE-zul).

"Sorry," Jasper said, blushing. He shook his head like a wet dog. Apple peels fell onto his shoulders.

"One of my first paintings was *The Procuress*. Even back then, my wife said I was too skinny. You see Jasper, I forget to eat sometimes."

*The Procuress* is thought to be one of Vermeer's first self-portraits. This was one of the first times the artist created an action scene instead of just a quiet moment.

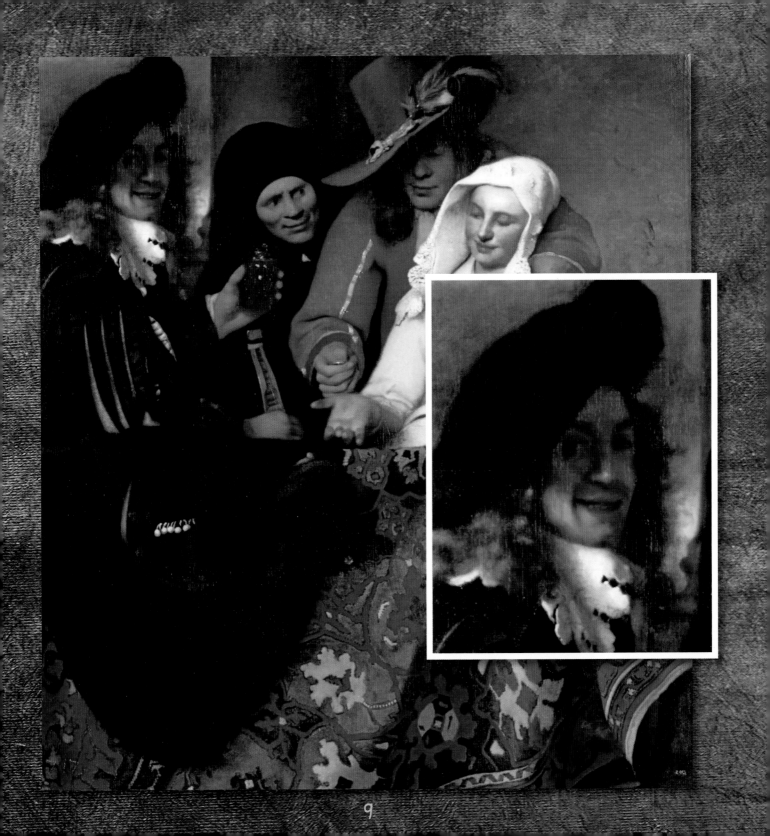

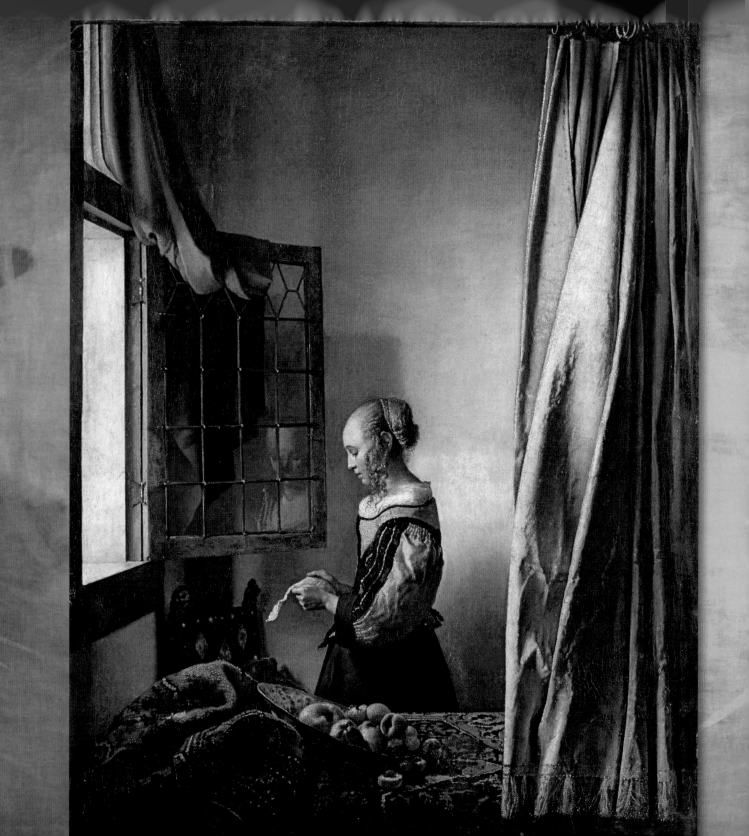

"When I painted *The Milkmaid,* my wife had to poke new holes in my belts! This painting here"—he pointed at his easel—"this is *Girl Reading a Letter at an Open Window.* Every day I work on it, Catharina shoves food in my hands!"

"Am I here to make you eat?" Jasper asked.

"Catharina says that if I must paint, and of course I must, then I must eat. Each day, you will come here. Catharina will give you food. You will make sure I eat it or dump it out the window if it is terrible. With your help, I shall finally have peace and quiet!"

*Girl Reading a Letter at an Open Window* (1659) was one of Vermeer's first attempts at mastering light. Notice how light falls across the girl's clothing.

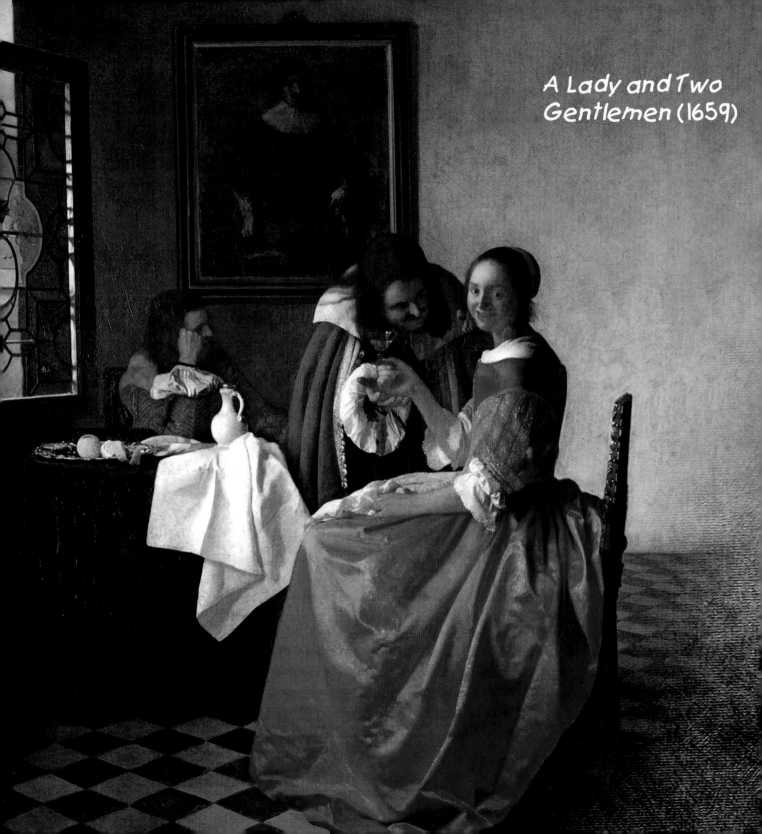

A Lady and Two Gentlemen (1659)

# Chapter 2
## Up Close or Far Away?

"I want to tell you about perspective **[per-SPEK-tiv]**." Vermeer waved Jasper over to look at his current painting. "People come to see my work because I can paint things to look close or far away by making them big or small. I did that with *A Lady and Two Gentlemen* and *The Little Street*."

"Is that like when I'm walking home, I can cover up the full moon with my thumb, even though I know it's way bigger than I am?" Jasper asked. In a flash, he won Vermeer's first smile.

"Exactly! Now, come here. I reward smart children. I'll let you help me clear the stage."

"What does that mean?" Jasper asked as Vermeer yanked the cloth from the table. The bowl of fruit fell off. Oranges rolled across the floor.

"Look at my workshop. It is a mess! I keep it this way to achieve **[uh-CHEEV]** perspective. Many of my paintings begin in a corner. That is THIS corner! I keep this corner of my workshop perfect. It can never be messy. If this corner is messy, then this is messy too." He pointed to his head.

"So the corner is your stage?" Jasper asked.

"I knew you were the perfect boy for the job!"

Finding the inspiration behind Vermeer's *The Little Street* (1658) became a worldwide mystery. Eventually, it was discovered that it was a small road in Vermeer's hometown of Delft. The road gave him the idea for this painting.

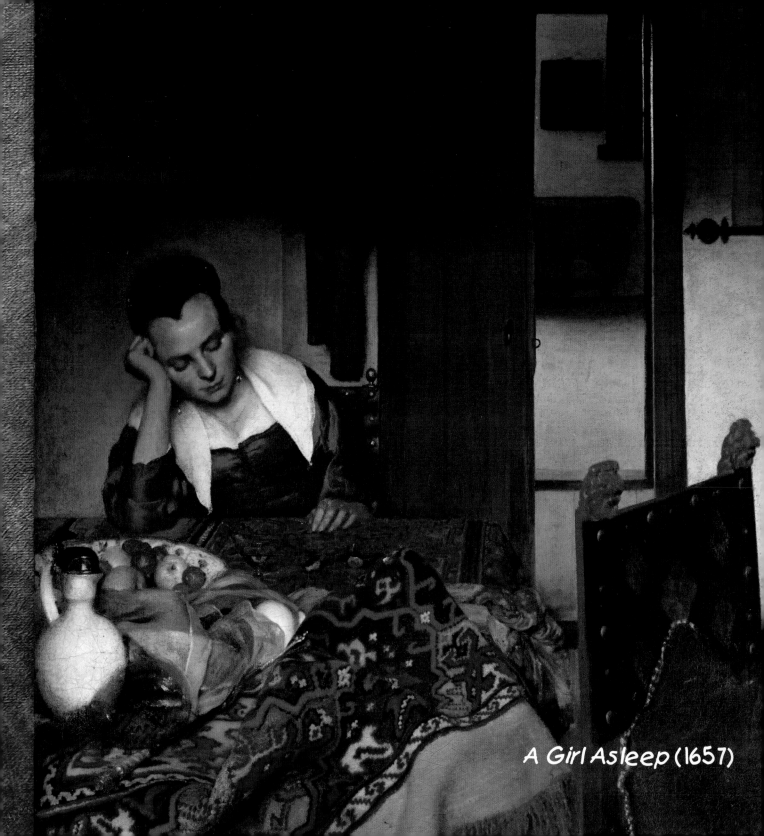

*A Girl Asleep* (1657)

## Chapter 3
## The Color Blue

Jasper went to Vermeer's home many times. One day, he brought one of his parents' apple pies. As a reward, Vermeer let him look at the older paintings.

"Do you have a favorite?" Vermeer asked. "Is it *Christ in the House of Martha and Mary*? Or perhaps *A Girl Asleep*?"

"I like the blue color." As soon as he said it, Jasper felt silly. It sounded like something a child would say.

Vermeer clapped him on the shoulder like a proud father. "Thank you, Jasper. You understand my mind in a way my wife does not. Come. I shall show you why you love this blue."

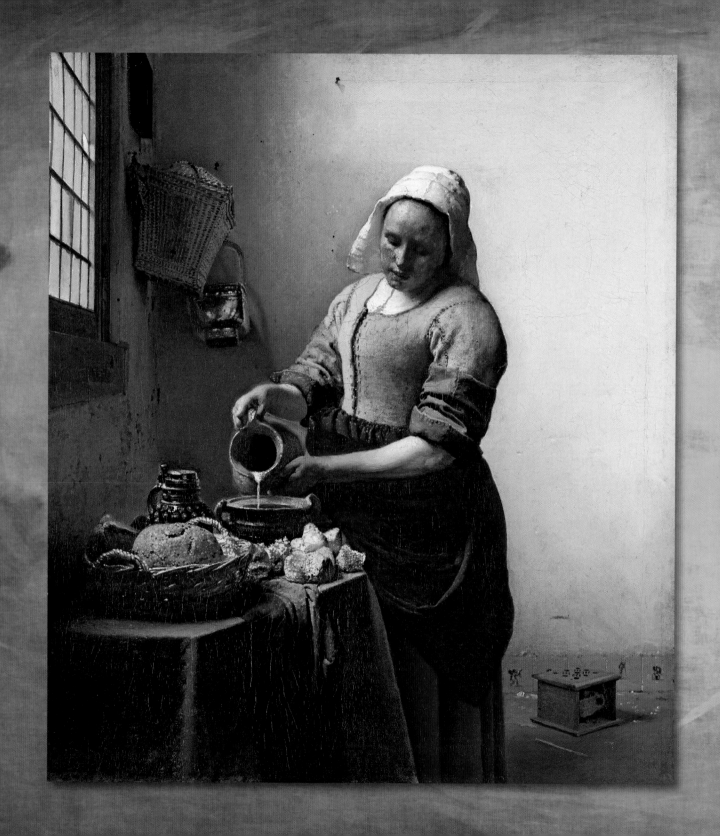

The artist led Jasper to a different corner of the workshop.
"Catharina says I should not use this color blue because it is too expensive [ek-SPEN-siv]. Look at this painting. This is *The Milkmaid*. I could have used azurite [AZ-yuh-ryt] for her skirt or the tablecloth, but I did not. Yes, azurite is cheap, but it is not a blue anyone could love."

Vermeer picked up a bowl of blue powder. "Look here! This is crushed lapis lazuli [LAP-is LAZ-yoo-lee]—a beautiful blue gemstone. I turn it into powder. Then I make a paint called ultramarine [UL-truh-muh-reen]. I use it in all my paintings."

When Vermeer painted people, he almost always preferred to paint the rich. *The Milkmaid* was an exception. She is a plain woman doing a household chore. This painting became even more popular those he did of the wealthy.

Lapis lazuli

Vermeer shook his head. "Catharina used to love this blue. Now she says it costs too much. She says, 'Paint doesn't feed the children.' "

"Why do you paint?" Jasper asked as they finished the pie.

"I paint to be remembered. We do not live on this earth long enough to be remembered. We must make a mark on it. You too, Jasper. You will not know me long enough to remember me."

But Jasper knew that he would never forget this great artist.

One of Vermeer's earliest paintings was *Christ in the House of Martha and Mary*. (1655). It is now the largest surviving Vermeer painting.

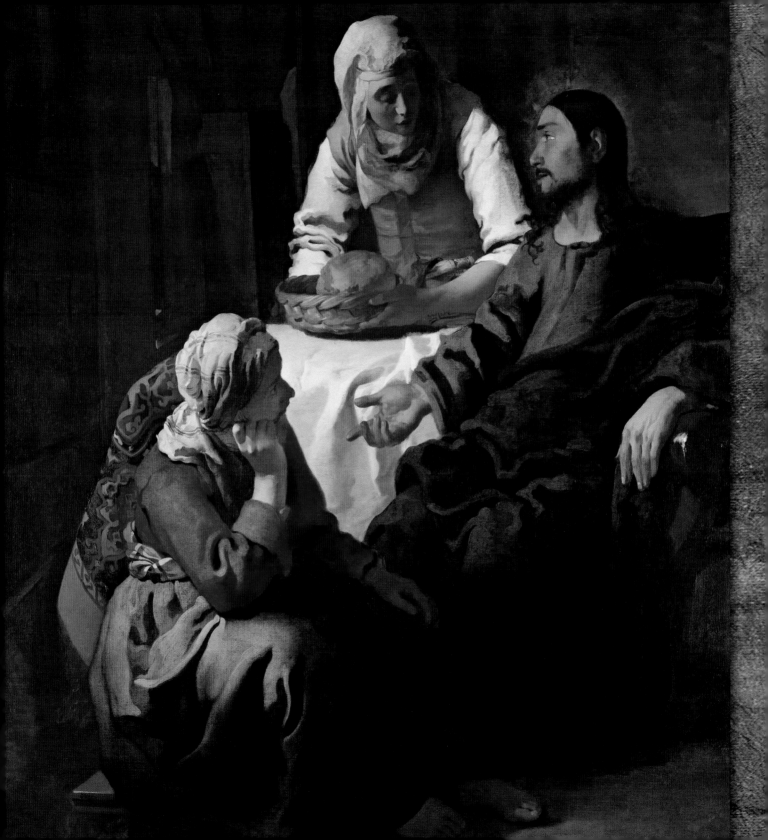

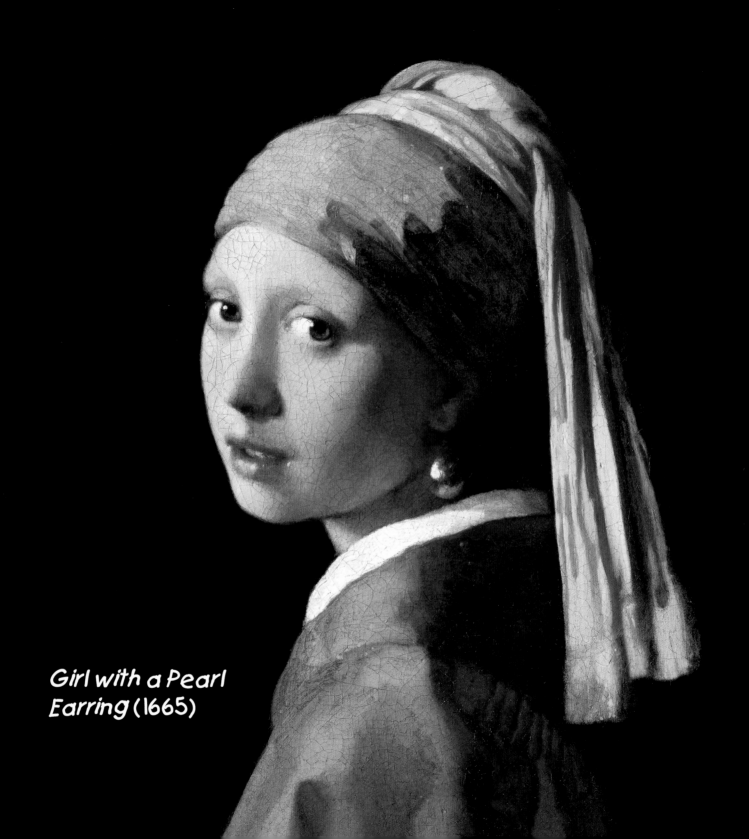

Girl with a Pearl Earring (1665)

# Chapter 4
## The Sphinx of Delft

In the following years, Jasper heard the townspeople call Vermeer "The Sphinx [SFINKS] of Delft" because he was so mysterious. When Jasper visited other towns, he was sad to hear that no one knew Vermeer's name or his paintings. The only ones who knew Vermeer were the other artists in the Guild of St. Luke. Jasper knew that the artist should have gone out to see people. If he had, he might have been known for more than just his most famous painting, *Girl with a Pearl Earring*.

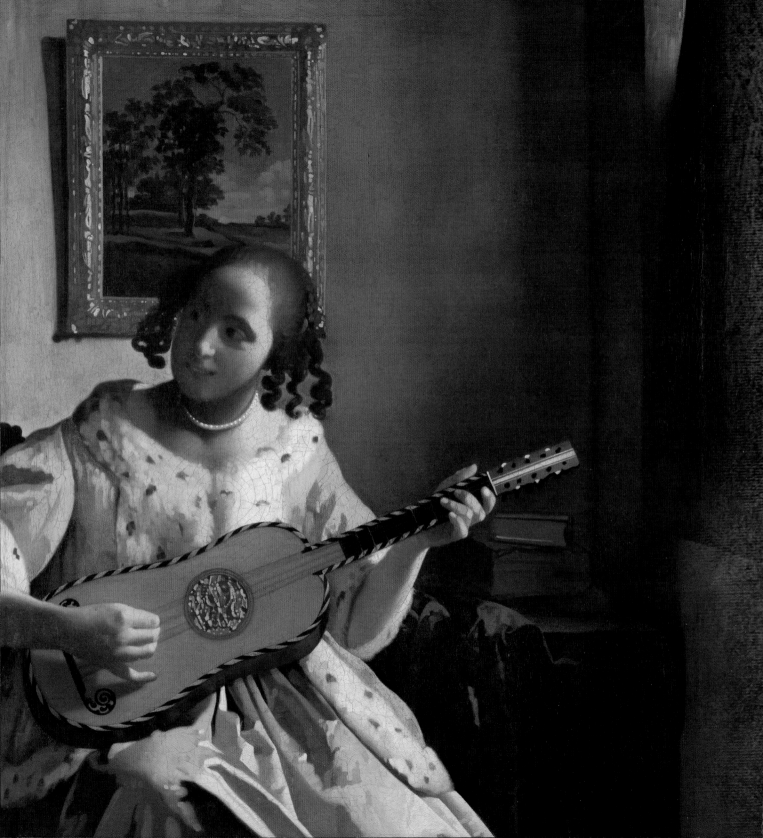

In 1675, Johannes Vermeer died. Jasper took an apple pie to Catharina to say he was sorry. In return, she told him how hard life had been. The family had no money left, so she was selling her husband's paintings. Jasper remembered Vermeer saying that paint could not feed children. Now, perhaps, it could.

Jasper walked home from his last visit to Vermeer's house. He was sad that the man with the messy workshop and perfect corners was gone from the world. Jasper looked up at the blue sky. It reminded him of Vermeer's ultramarine.

"I'll remember you," he promised.

In 1974, Vermeer's *The Guitar Player* (1672) was stolen from a London museum. The thief broke a window and then climbed a 10-foot wall, all to escape with the painting! The artwork was found, undamaged, a few weeks later.

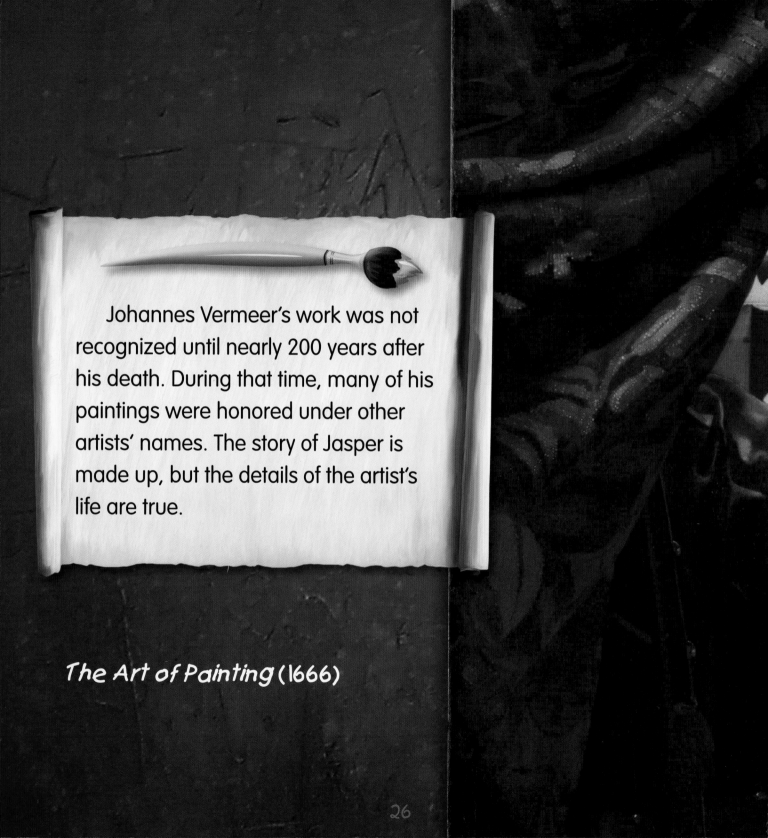

Johannes Vermeer's work was not recognized until nearly 200 years after his death. During that time, many of his paintings were honored under other artists' names. The story of Jasper is made up, but the details of the artist's life are true.

*The Art of Painting* (1666)

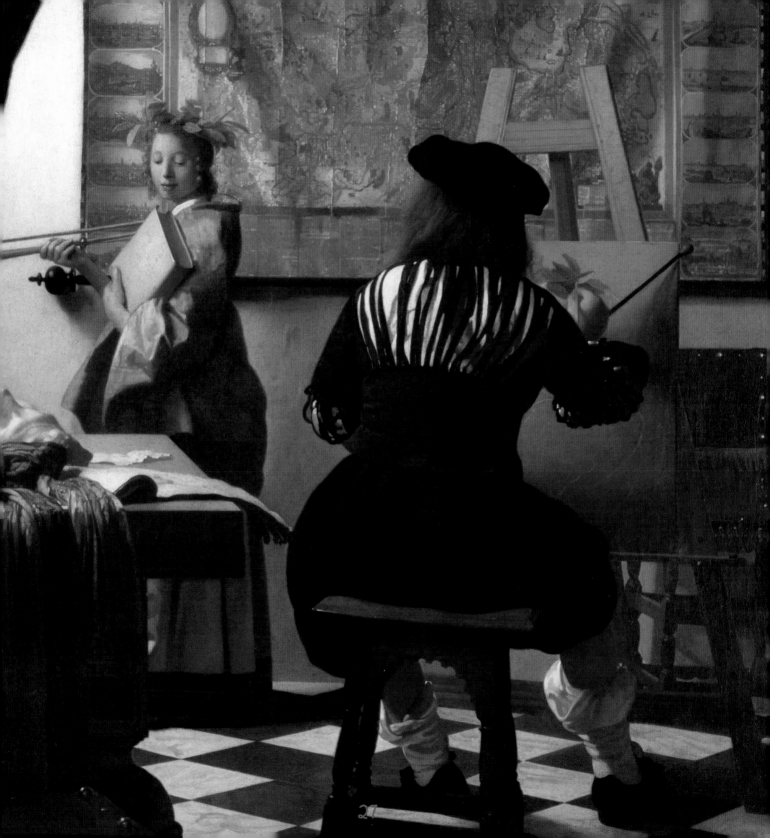

**1632**    Johannes (or Jan) Vermeer is born in Delft, Holland, in the fall.

**1652**    He joins the Guild of Saint Luke, a group of painters.

**1653**    Vermeer marries Catharina Bolnes. They move in with Maria Thinn.

**1654**    Many painters move to the large city of Amsterdam for more jobs. Vermeer stays in Delft.

**1656**    Vermeer paints one of his first masterpieces, *The Procuress*.

**1660**    He is appointed a headman of the Guild of Saint Luke.

**1672**    France invades Holland.

**1675**    Vermeer dies.

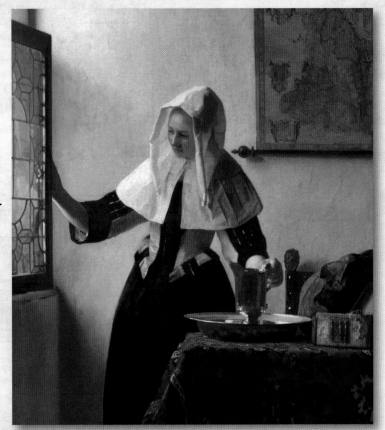

Woman with a Water Jug, 1662

# Further Reading

## Works Consulted

Buvelot, Quentin, and Desmond Shawe-Taylor. *Masters of the Everyday: Dutch Artists in the Age of Vermeer.* London: Royal Collection Trust, 2015.

Giltaij, Jeroen. *The Great Golden Age Book: Dutch Paintings.* Zwolle, Overijssel, Netherlands: W Books, 2016.

Janson, Jonathan. *Essential Vermeer 2.0.* http://www.essentialvermeer.com

Schneider, Norbert. *Vermeer.* Cologne, Germany: Taschen, 2016.

Schutz, Karl. *Vermeer.* Cologne, Germany: Taschen, 2015.

Snyder, Laura J. *Eye of the Beholder: Johannes Vermeer, Antoni Van Leeuwenhoek, and the Reinvention of Seeing.* New York: W.W. Norton and Company, 2016.

Wieseman, Marjorie. *Dutch Painting.* London: National Gallery, 2014.

## Books

Etienne, Vincent. *Vermeer's Secret World.* New York: Prestel Publishing, 2008.

Raczka, Bob. *The Vermeer Interviews.* Minneapolis, MN: First Avenue Editions, 2010.

Wenzel, Angela. *13 Artists Children Should Know.* New York: Prestel Publishing, 2009.

Wood, Alix. *Johannes Vermeer.* London: Windmill Books, 2013.

## On the Internet

Online Vermeer Puzzles
   http://www.jigzone.com/gallery/2559D3E.1D5DE85

**achieve** (uh-CHEEV)—To do something; to reach a goal.

**azurite** (AZ-yuh-ryt)—A soft blue stone used to make blue paint.

**easel** (EE-zul)—A wooden stand.

**expensive** (ek-SPEN-siv)—Costing a lot of money.

**lapis lazuli** (LAP-is LAZ-yoo-lee)—A blue stone used to make blue paint.

**perspective** (per-SPEK-tiv)—A way of drawing or painting that makes objects look closer or farther away.

**sphinx** (SFINKS)—A mysterious creature that had the body of a lion, wings of an eagle, and face of a human.

**ultramarine** (UL-truh-muh-reen)—A blue powder made from lapis lazuli.

# Index